Floral
Wood Carving

FULL-SIZE PATTERNS AND COMPLETE INSTRUCTIONS FOR 21 PROJECTS

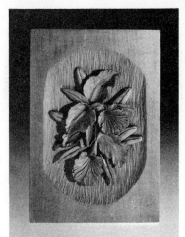

MACK SUTTER

DOVER PUBLICATIONS, INC., NEW YORK

To Genevieve,
for her encouragement and for the many years
during which she has been patient and forgiving
of my sawdust and wood chips.

ACKNOWLEDGMENT

E. J. Tangerman's many books and magazine articles, together with his personal instruction, have made him the dean of woodcarving in America. His two classic volumes that have been reprinted by Dover—*Whittling and Woodcarving* (Dover 20965-2) and *Design and Figure Carving* (Dover 21209-2)—are still considered as outstanding guides to good carving. They have been inspirations to me as teacher and artist for many years.

Tange, we thank you, and please accept my special thanks for helping me put together the present book.

Floral Wood Carving: Full-Size Patterns and Complete Instructions for 21 Projects is a new work, first published by Dover Publications, Inc., in 1985.

Library of Congress Cataloging in Publication Data

Sutter, Mack.
 Floral wood carving.

 1. Wood-carving—Patterns. 2. Decoration and ornament—Plant forms. I. Title.
TT199.7.S88 1985 736'.4 84-21174
ISBN-13: 978-0-486-24866-0
ISBN-10: 0-486-24866-6

Manufactured in the United States by Courier Corporation
24866612
www.doverpublications.com

FOREWORD

H. M. Sutter and I have worked together for a long, long time. He has borne the first name Harvey for a year longer than I have suffered with Elmer. Neither first name is worthy of mention except under duress. Mack has been teaching about the same amount of time as I have, but my teaching was in books, and his was in person. He started at the University of Wichita, Wichita, Kansas in 1934, but says he taught without a textbook until my *Whittling and Woodcarving* was published in 1936. Wood carving wasn't a livelihood for either of us; it was an avocation.

We didn't meet until ten years ago—it seems to me much longer than that—when we both embarked on the *Wunderjahr* of the National Wood Carvers Association to Europe. Mack intrigues me because he gave up the opportunity to admire Rembrandt's famous *The Night Watch* in Amsterdam (made famous by Dutch Masters cigars) to seek out a relief carving or three by Grinling Gibbons, the English master. Mack is at heart a relief carver, whether or not guides understand him.

Mack was heavily involved with Government for most of his working life. Early on, he was in the Bureau of Indian Affairs, and became a friend of Ben Hunt, the fabled carver of Indian-motivated pieces for the Boy Scouts. He later became a division chief for the Bureau of Reclamation of the Department of the Interior, in Washington, D.C. Then he became assistant to the administrator of Bonneville Power Administration, and moved to Portland, Oregon, where he has lived for the past twenty-five years, much to the benefit of that city. There he continued his interest in wood carving, working out with his sons a mild sort of business in which they produced and sold neckerchief-slide blanks to Boy Scout camps. The business helped toward college expenses, I hope, but I fear that the father of the family was not too practical about it. I recall visiting him and finding that he had just donated some 40,000 blanks for neckerchief slides for a Boy Scout Jamboree. However, despite such profligacy, Mack became, ultimately, assistant to the chief engineer at Bonneville, a post from which he retired seventeen years ago.

In Portland, he has taught all kinds of classes in wood carving and sculpture, including a number of free classes for potential instructors. He organized, with several friends, the Western Woodcarvers Association and has been closely allied with it since, serving several terms as president. It has now more than five hundred members and is probably the largest and most active unit in the National Wood Carvers Association. Mack is still teaching, summers at the Sitka Art Center near Otis, Oregon, and winters at Portland Community College, as well as taking part in shows and exhibits—and organizing a goodly number of them.

Some years ago, he felt that available tools were too thick and heavy for this kind of relief carving, so he forged his own and worked out a way of sharpening them by buffing. I've used some of them for years with great success. Several years back, he convinced one tool company to make tools to his specifications. He's now giving demonstrations on sharpening, as well as carving, and doing a myriad of other things, including corresponding regularly with me.

Thus it is with the greatest of pleasure and admiration that I introduce this book of patterns that Mack has carved and taught, together with his notes and suggestions for each. The flowers are presented roughly in order of carving difficulty. I have used his patterns and ideas in my own classes for several years with great success. I know you will find them helpful, too.

E. J. Tangerman

CONTENTS

INTRODUCTION

The twenty-one full-size patterns contained in *Floral Wood Carving* represent a variety of flowers found mainly in the Americas. These patterns are ready to be transferred to wood panels by pinning a sheet of clean carbon paper, black side down, over the wood panel and inside the carving area allotted to the project, then similarly pinning down the pattern and tracing the outline of the pattern with a stylus. The instructions for these relief carvings along with the photographs of the finished projects will guide the careful wood-carver to a satisfying result. It should be noted that the projects are presented in an order of increasing difficulty.

All of the finished projects were carved in basswood except the gaillardia (paulownia) and the thistle (Honduras mahogany). The gaillardia carving also retains its native bark on two edges. Several of the projects when completed may be tinted (pine cone, gaillardia, torch ginger and iris) for added effect. Some patterns require applications of a special shellac mixture (see page 12) to strengthen thin edges of the carving, especially when working with soft wood, and to prevent smashing when applying a punch for cross-hatching. All the projects (except the rose and gaillardia) are undercut and three projects (bluebells, torch ginger and lily of the Aztecs) require the use of small, thin blades and gouges.

Dover's Pictorial Archive Series contains many books with illustrations that can also be used as designs for wood-carvers. The designs for five of the patterns contained in *Floral Wood Carving* (gaillardia, torch ginger, water lily, tulip and iris) are from Dover floral books.

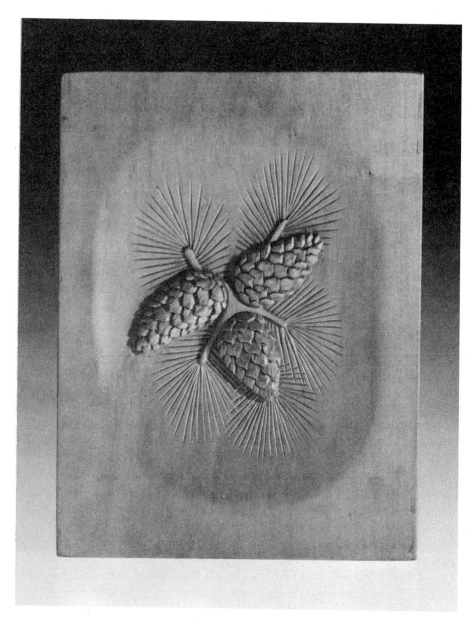

A Pine Cone Cluster

Contrast results from the combination of rounded cones and linear needles.

Our eyes sometimes tell us one thing when another is true. In this design the pine needles are actually grooves in the surface rather than tiny ridges, which would be difficult to carve, but they look quite natural. Also, the cones are relatively flat, but the individual scales are "stepped" or shingled and the cone edges are curved, so the cone becomes round to the eye.

I used 2 × 10 × 12-in. basswood for the panel, but this pattern can work on anything from 8 × 10 in. up, and the wood need not be more than 1 in. thick. The panel can be displayed either horizontally or vertically. Because the background actually must be used for the needles, it should slope in gradually to the cone group, with no definite border. Lay out only the cones and stems, because any sketch of needles will be cut away immediately. Note that the branches and stems are at a lower level than the bulge of the cones. Much of the effect of roundness is obtained by sloping each side from the outer tip of the cone so it

appears to pass under the scales beyond it; study the photograph for a moment or two and you'll see what I mean. Work carefully in carving the scales because it is easy to split away surface wood. Grounding about ½ in. can be deep enough. Slope out the background around the cones and smooth it before drawing in and cutting the needles. Needles can be cut with a V-tool or veiner, but be sure the tool is very sharp or it will tear the surface.

If desired, the design can be tinted, or the needles and seed steps made to stand out more than they do in the photo by "antiquing." This means sealing the surface by a coat of flat varnish or the equivalent, then brushing on a darker stain, a small area at a time, and wiping it off immediately so some stain is left in the carved lines. This is the equivalent of the darkening that sailors do on scrimshawed ivory, but, unlike ivory, the wood will soak up stain in all areas if it is not sealed first.

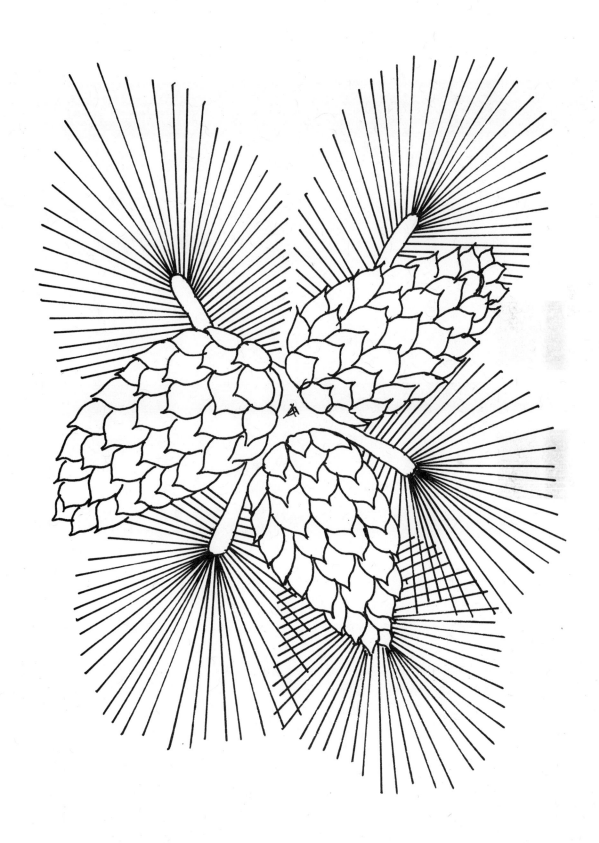

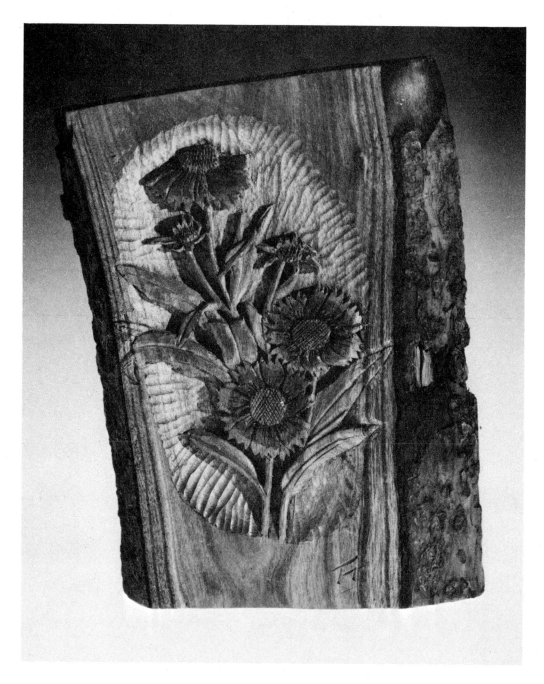

Gaillardia as a Cameo

Not-quite-square panel retains bark; tinting petals helps distinguish the flowers from daisies; darker heartwood gives cameo effect.

Gaillardia (*Gaillardia aristata*) is a familiar summer-blooming perennial in many gardens, having a red center and petals that shade to yellow at the tips. This representation of the flower includes several variations from the expected form. The wood itself is unusual: It is paulownia, a Chinese tree named after Princess Anna Paulovna, daughter of the Russian czar Paul I. *Paulownia tomentosa* has long been naturalized and grown for its showy purple-violet foxglove-like flowers, borne in a pyramidal panicle. Also called the royal princess tree, it was imported to the United States about fifty years ago, and has grown so rapidly and well that it is now beginning to be lumbered in North Carolina.

This carving (by E. J. Tangerman) is quite shallow, with the background set in only ¼ in., so no undercutting is necessary. Also, because the heartwood is darker than the growth wood, the subject is darker than the background, to give a cameo effect. This is amplified—and the flower distinguished from its daisy look-alikes—by staining the petals darker brown at the center, but not adding color or stain otherwise. Also, the not-quite-rectangular shape of the original slab and its bark on two edges have been retained, the bark being prevented from crumbling by several coats of satin-finish varnish. Panel size is roughly 1 × 8½ × 11 in.

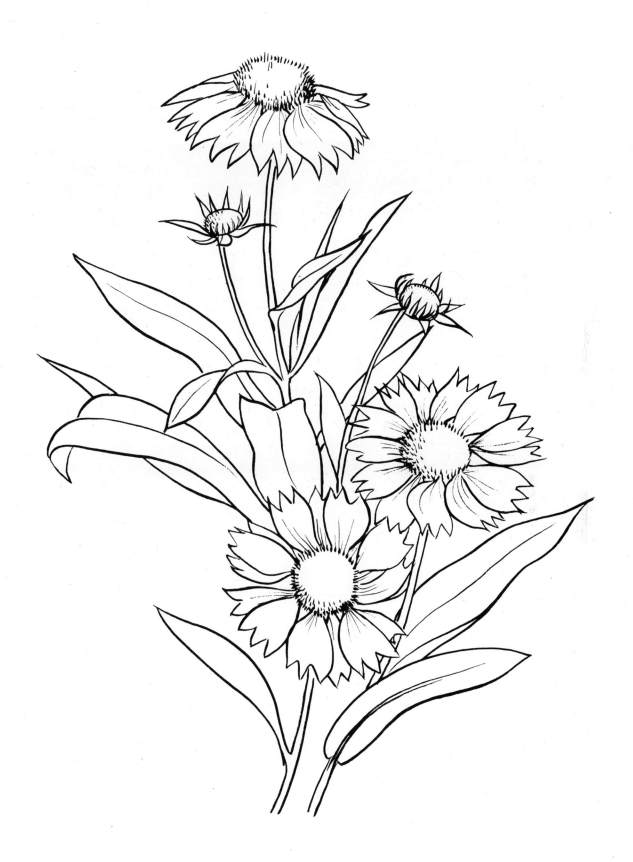

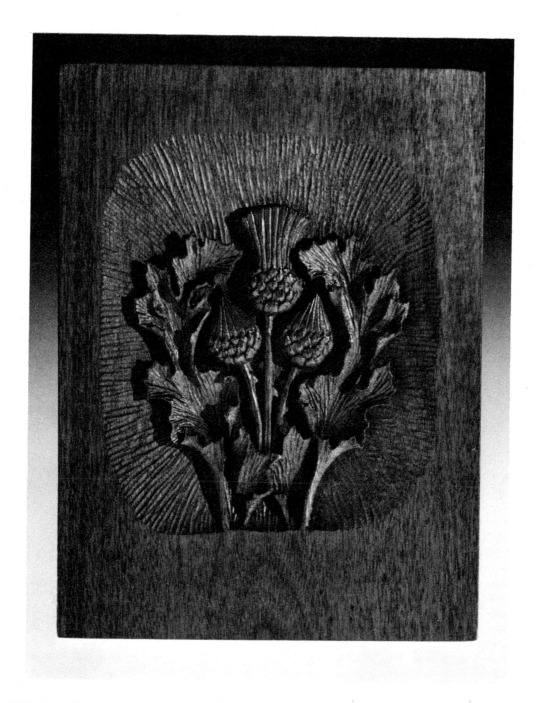

The Thistle Is Prickly

This formal and somewhat stylized arrangement recalls Scotland.

The Scotch or cotton thistle (*Onopordum acanthium*) is very familiar to Americans and Canadians; it flourishes in wastelands and is prickly enough to protect itself against casual damage. It is also the Scottish national and heraldic flower. As a carving project, it could be somewhat difficult because of the spines, but here I avoided them except as a suggestion of spurs on the flower stems and indentations along the edges of leaves.

In contrast to most of the other designs, this one is balanced and formal; it can be the central element of a larger carving. The curling and crenellated form of the leaves and the "shingled" arrangement of the flower bulb require particular care. I chose Honduras mahogany for the wood, the piece being $1 \times 11 \times 14$ in.; it can, however, be somewhat smaller and also either oval or circular in shape.

The background should be cut relatively deep to allow for the convolutions of the leaves and to make certain that the flower bulbs are rounded. I backgrounded, therefore, to ¾ in. depth and undercut, particularly behind leaves and stems, to make the leaves stand out against the dark wood. The background is textured with a large flat gouge. Leaf veins are put in with a veiner after the surfaces have been textured with a small flat gouge. Note that the two leaf stems bleed into the bottom border, which is 3 in. wide. Side borders are 1 in., and the top 2 in.

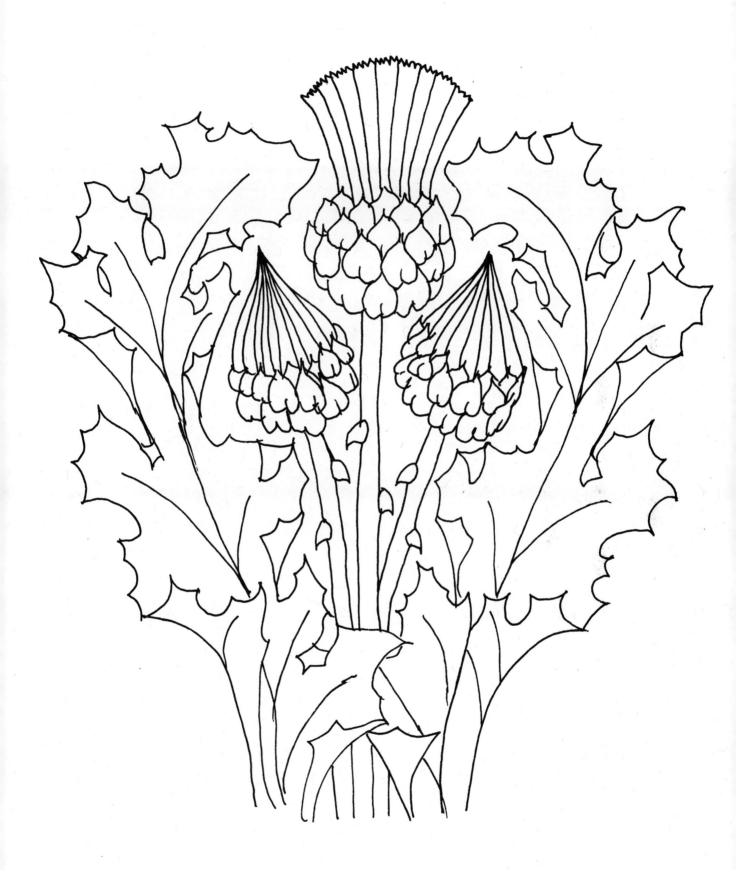

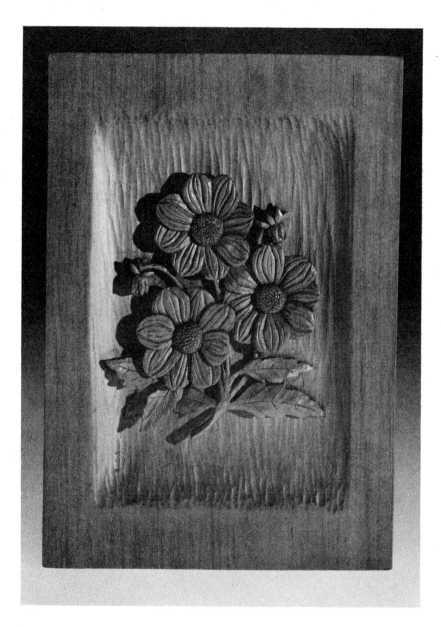

Dally with a Dahlia

An American food herb named after a Swedish botanist.

The dahlia, named after Swedish botanist Anders Dahl, is one of a small genus of tuberous-rooted herbs of Mexico and Central and South America. Most of our many horticultural varieties are descended from *Dahlia pinnata*, and are known by such names as Attraction, Ballet Girl and Bianca. There are also a number of garden classes: decorative, pompon, anemone-flowered, duplex and dwarf, which is our pattern. All have deep rays of red, and there is a deep red-purple dye called dahlia because of its similarity in color. The dahlia was a food crop among the Indians of Central and South America—in fact, it is still eaten by the Guahibo Indians of Colombia.

The design is familiar and attractive and does not require deep undercutting. It also does not require particularly deep grounding, although there are three flowers, one slightly behind another, and buds behind them. Some of this depth can be faked by dropping covered petals back slightly while the flower itself is at a higher level. The core of each flower requires cross-hatching

which can be done with a V-tool, a 1/16-in. #9 gouge or a punch. I prefer the punch, which I make by squaring the end of a finishing nail, then center-punching the square so I can drill a small-diameter hole in it. Then I sharpen the sides of the square until the edges are fairly sharp, so the punch will cut the wood slightly. To keep the wood from smashing under the punch, I "stabilize" the flower core by coating it with a mixture of 1 lb. of shellac to three gallons of alcohol, commonly called #3 shellac. We actually thin this still further by adding one part of denatured alcohol to two parts of #3 shellac. We coat the panel with this mixture—which we call "#5 shellac"—immediately after the design is drawn, to keep the surface clean. We also coat newly carved surfaces after each carving session and give several coats to delicate areas before attempting to carve them. This strengthens the wood and dries quickly. Our earlier attempts to stabilize with polyurethane varnish did not work so well because the varnish took a long time to dry and tended to discolor the wood.

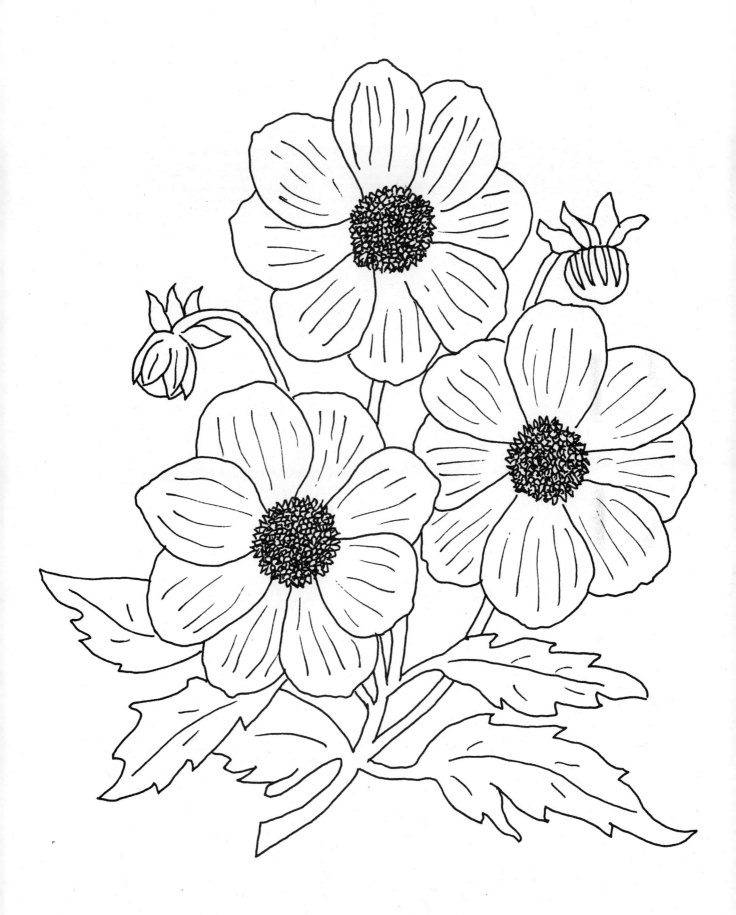

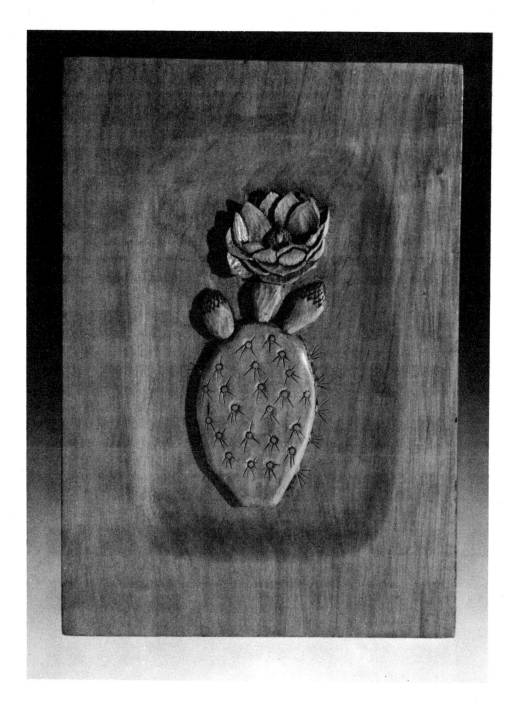

Prickly Pear

An edible cactus stripped of its spines and skin, the prickly pear leaf is used to make *nopalitos*. The spines involve a carving trick.

The prickly pear (*Opuntia chlorotica*) is a cactus that is widespread in the semidesert areas of the southwestern United States, Mexico, Central America and the Galápagos. Despite its spines, it is planted as a food for livestock, and its leaves, peeled to remove the spines and split into narrow strips, can be cooked to make a dish that tastes something like stringbeans—the Mexican dish called *nopalitos*, the plant itself being called *nopal* in Spanish. One variety, *Opuntia tuna*, yields an edible fruit, the tuna, in Central America and Mexico.

The blooms of the prickly pear grow directly from the leaves,

as they do in other cacti. The hairlike spines on the thick leaf would be impossible to see if carved, but they can be simulated by cutting small V-grooves radiating from circular buttons carved in the smooth leaf surface. The bloom must be flattened somewhat to allow reasonable depth in the grounding, but multiple layers of petals and a cup-shape corolla with bottom "button" make some undercutting necessary. This is not a difficult carving despite the "trick" spines. It can be made in 1-in. basswood quite easily.

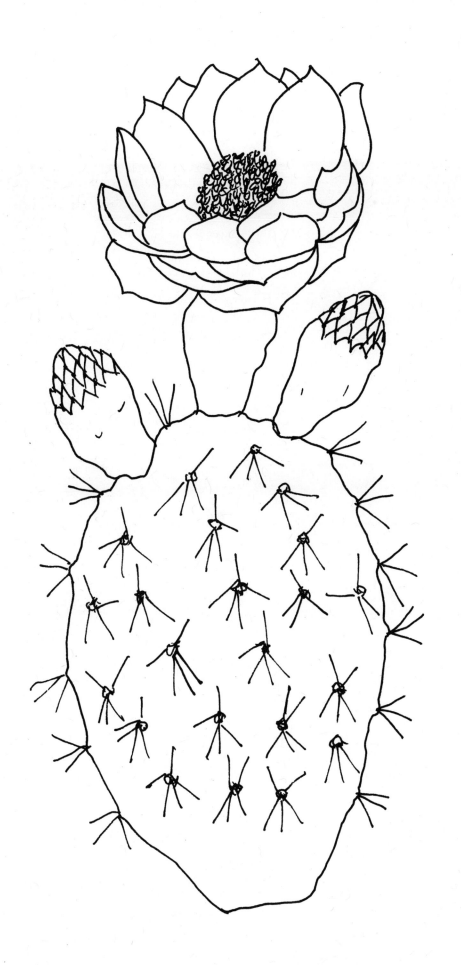

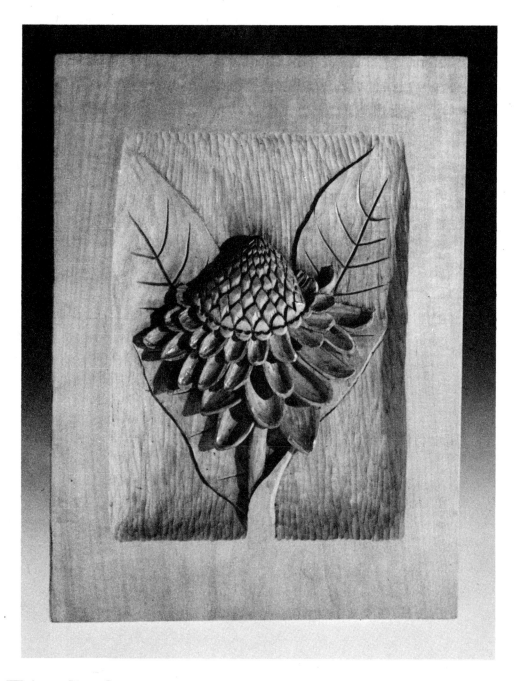

Try a Torch Ginger

Spectacular South Seas bloom has little undercutting.

This spectacular design is not difficult to carve, even though it appears to be quite complex. It can also be tinted quite easily. The torch ginger (*Phaeomeria speciosa*) is a South Sea Islands flower which has a big red or pink bloom.

Undercutting does not have to be extreme on this design; the leaves, in fact, are only about ⅛ in. above the background and fade into it at the edges, except for the wraparound of the stem beneath the bloom. The central portion of the flower is a shaped mound, reminiscent of an artichoke but straight-sided rather than bulging and with the pointed petals bulging less. The collar of larger petals is somewhat irregular and requires that each be dished in behind the one above it. This requires some careful gouge work with half-round gouges of proper sizes.

On carvings such as these, I use my thin tools, particularly the numbered gouges, which are numbered according to the number of sixteenth-inches in their diameter or sweep. Thus, a #1 has a ¹⁄₁₆-in. diameter curve inside, a #2 has a ⅛-in. diameter curve and so on. I sharpen these tools and the firmer with a longer-than-normal bevel, and use the exact sweep desired for such cuts as the interiors of petals. Also, I take particular care not to push the tool, especially a firmer or flat chisel, in too deeply when making stop cuts around the design or in modelling, because this will leave unsightly cut marks on the finished work. I rarely use a mallet in modelling in basswood, and when I do it is a soft-faced one. However, you may find it more comfortable to use such a mallet, because it permits very close control of the cut.

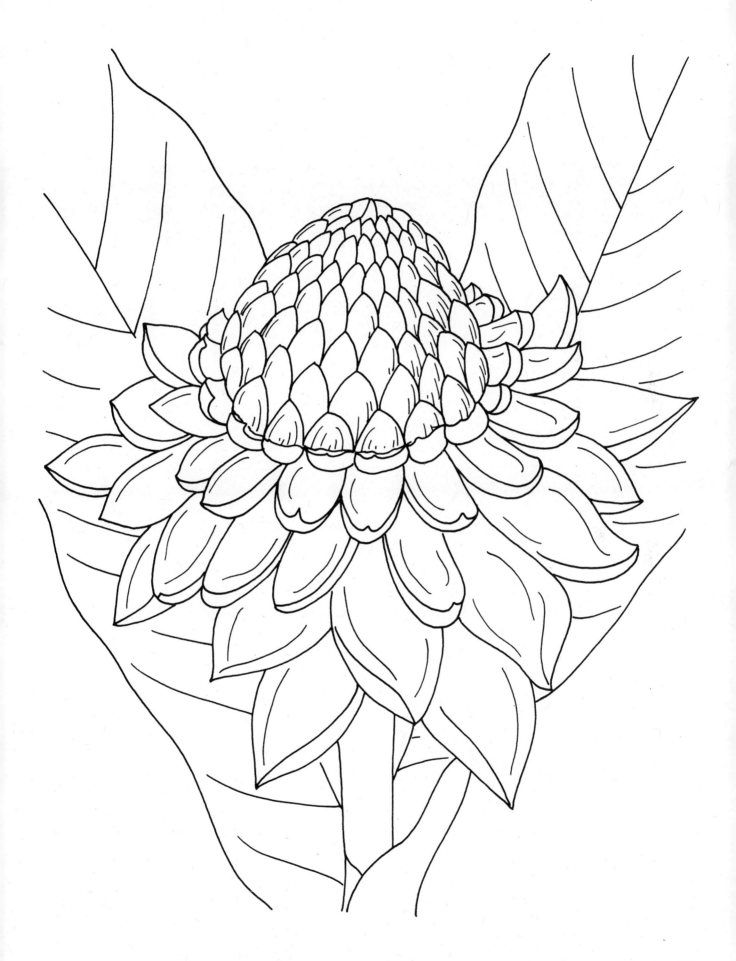

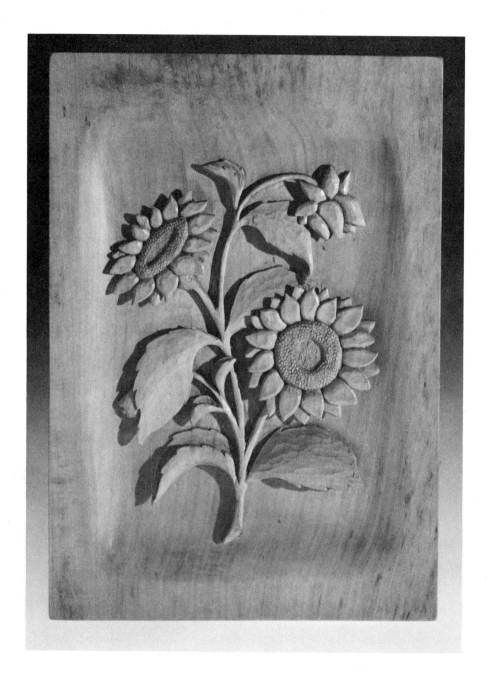

Sunflowers

A cash crop familiar all across America, the sunflower is a good carving project.

The Kansas state flower and the floral emblem of Peru, the sunflower (*Helianthus annuus*) is familiar all across the country. It can grow to a dozen feet tall with flower heads a foot across that turn with the sun. It is also very important commercially, its seeds making an annual crop of more than seven million tons. About 300 million gallons of oil are extracted and sold to the paint, varnish, soap and pharmaceutical industries, and to the food industry for salad oil, margarine, synthetic lard and oil cake for fodder. The meaty seeds are a favorite human snack toasted; cardinals and other birds love them without toasting. Its leaves were once used for a tobacco substitute, and the stems provided a silky fiber, but now the stalks and leaves are converted into silage for winter cattle feed.

This panel shows two blooms and a bud. There is a double row

of pointed petals outside the central corolla, so the flower is quite complex. The inner surface is in two levels and must be stippled by cross-cutting with a V-tool, fine veiner or punch (see dahlia for a description of how to make one); two levels are also required in the petal circle, so I cut the background back about ¾ in. The blossom at an angle to the viewer also provides a challenge. To make the flowers and leaves stand out, they are undercut somewhat. This carving is in basswood and measures about 1 × 11 × 14 in. The background is carved and sanded smooth, while tool marks are left on such surfaces as the leaves. I elected to show the divided level of several partially open leaflets, but not the veining of the open leaves. If you want the added detail of the veining, it can be done with V-tool or veiner.

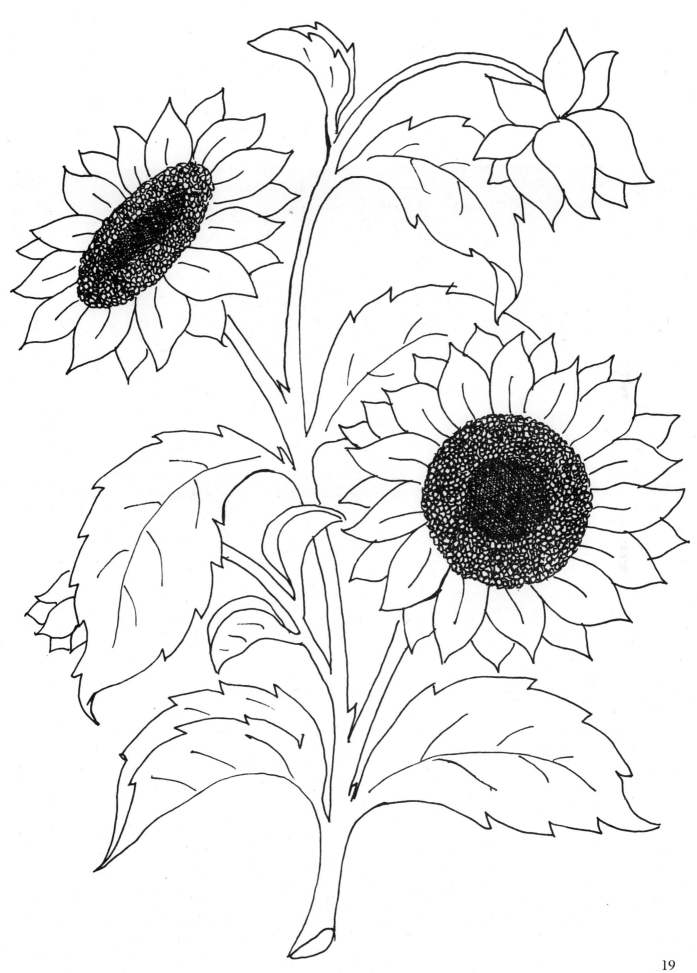

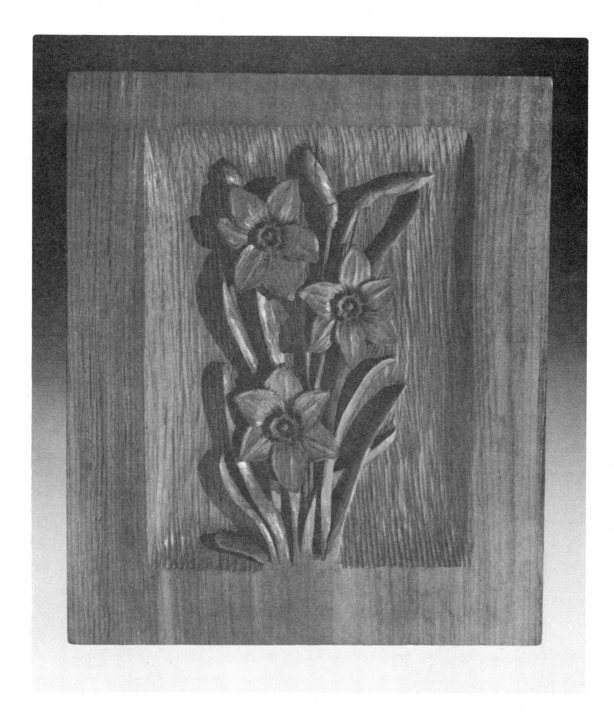

"A Host of Golden Daffodils . . ."

An Old World flower now very familiar here—and easy to carve.

Greek legends have it that Echo pined away and died because of her unrequited love for Narcissus, a beautiful youth. Nemesis punished Narcissus's indifference by making him fall in love with his own reflection which he saw in a pool of water. Narcissus was then transformed into the Old World flower which bears his name. There are many variations in this family of bulbous herbs, *Amaryllidaceae,* including the narcissus (which this is), the daffodil and the jonquil, all well-known in cultivation. The word daffodil (asphodel in the Middle Ages) was once used for all narcissi, but now is restricted to the simple yellow variety with the long and large trumpet-shaped corona. The jonquil, a south-

ern European and Algerian import, has a short corona and a long neck behind the collar of petals. The petals can be in a single or double row, in yellow, white or mixed.

This pattern is for *Narcissus jonquilla,* which has a short corona and no edgewise petals. There is some undercutting behind the edges of the petals, but the edges themselves are fairly thick, so not particularly fragile. Many petals are also supported by the leaves behind them, and the leaves themselves, which are apparently edgewise, are actually fairly thick. Grounding need be only ½ in. or so for this carving.

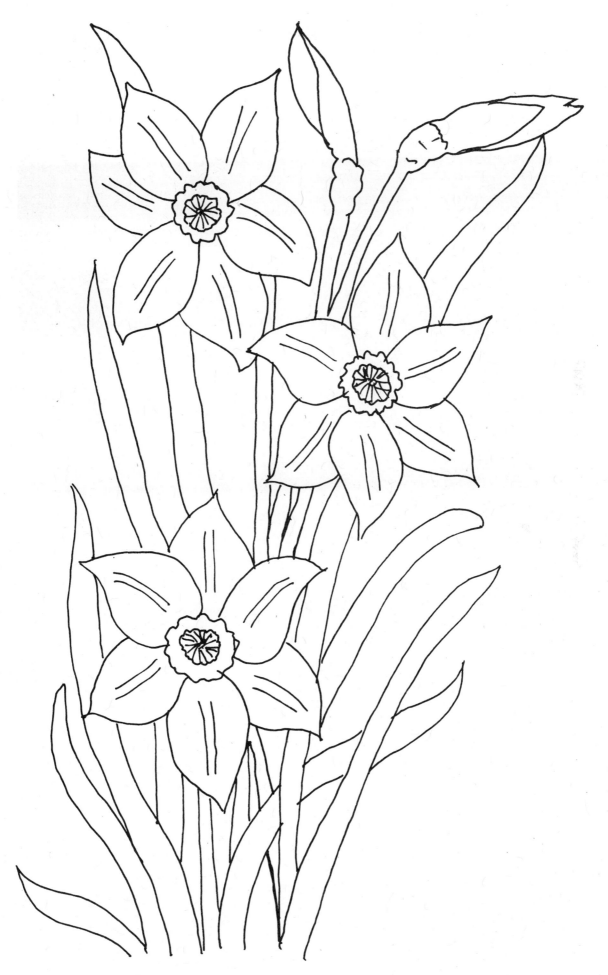

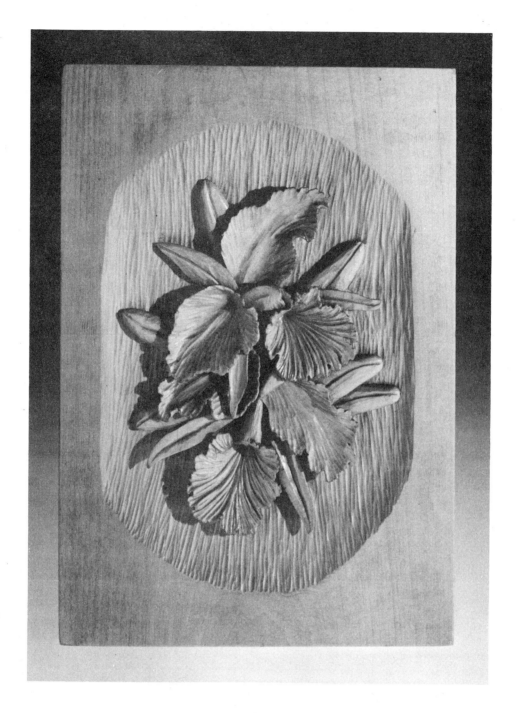

An Orchid Corsage

Many carving levels and frilly petals create a complex composition.

Two showy orchids and their leaves make this bouquet. While orchids come in many shapes, sizes and colors, the most familiar one in florist shops is the Cattleya.

This pattern can be used either as published here, upside down or turned 90 degrees clockwise, just as you prefer, so the finished panel can be hung either horizontally or vertically. It can be tinted or not, again as you prefer. It should be copied on a 9 × 12-in. or 11½ × 14-in. panel; I chose the latter, and used 2-in.-thick basswood. The subject has also been carved in 9 × 12-in. walnut 1 in. thick, although in that case the background could be lowered only ⅝ in. It is advisable to sketch in all the principal lines; they will not be destroyed in setting-in the background. I curved the background down in a flat-sided oval, setting-in the entire composition before I began modelling.

In modelling the flowers and leaves, it is essential constantly to remember the various overlaps, as well as the fact that there are no plane surfaces; each petal and leaf is composed of compound curves, and the petals have crinkled surfaces as well. Some undercutting is done around edges of petals and leaves, and leaf edges are curled. This was one of my early panels, carved with thin-bladed tools that I made myself, so it has also been my favorite.

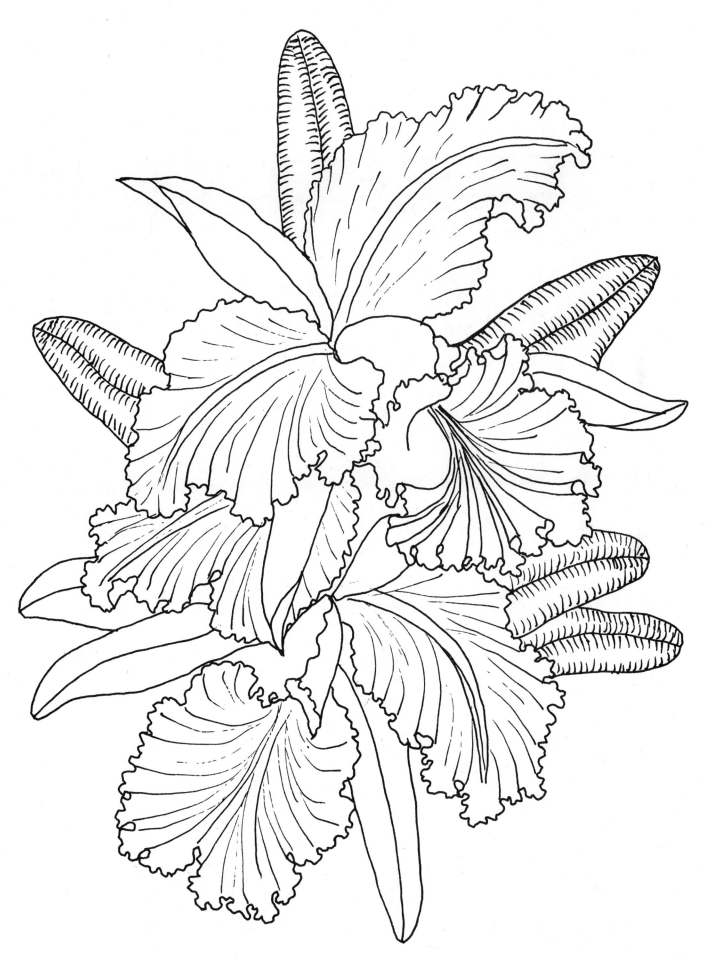

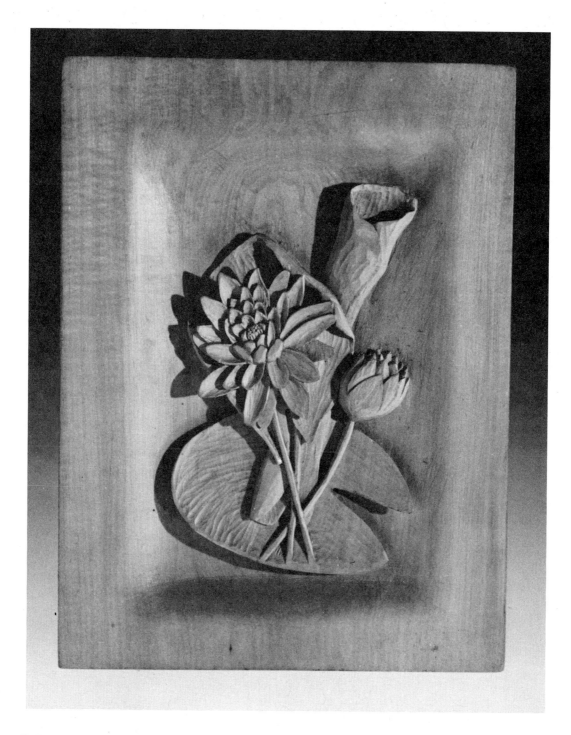

To a Water Lily

Multiple surfaces and varied textures are involved here.

Water lilies are our most spectacular native water flowers. They are actually quite hardy plants and have a pleasing scent as well as appearance. This scent attracts night-flying moths which come to them for nectar, meantime pollinating plant to plant. Petals of the common species *Nymphaea odorata* are a waxy white, in several layers forming nested cups around a yellow center.

This pattern results in a fairly complex panel to carve because of the many levels, including the big curled leaf in back. This must be faked, of course, showing full roundness and curvature at the top but flattening behind the flower. Also, the petals of the flower should be supported by whatever is behind them; they can't be cut free because of the danger of breakage. Thus, the leaf immediately behind the flower has a curled-up edge to support outer flower petals. Undercutting in this area must be very carefully done to retain as much thickness as possible immediately behind edges. Leaf inner surfaces are groove-finished with a small flat gouge to give the effect of the creasing of the actual lily pad.

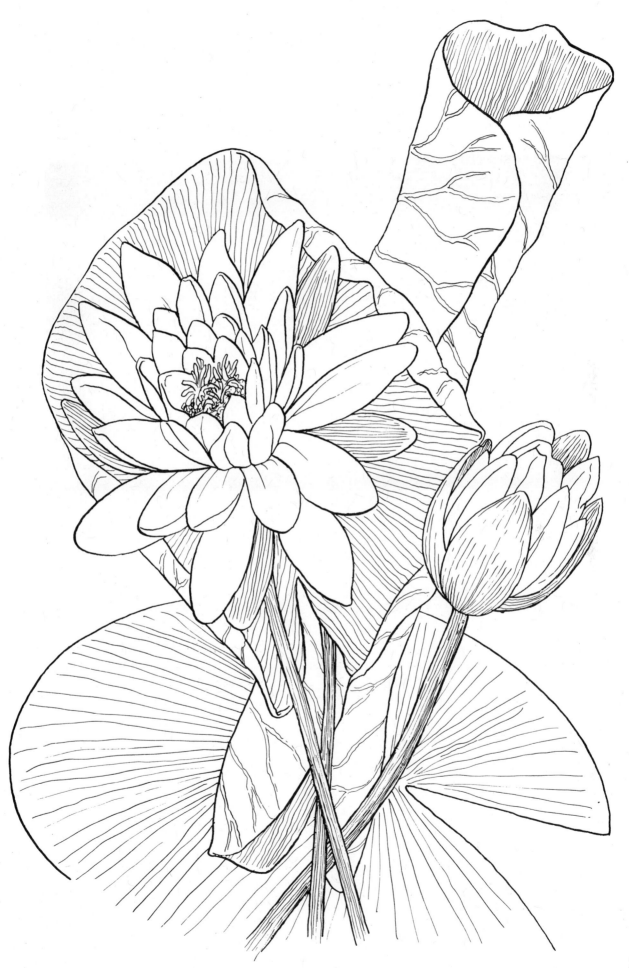

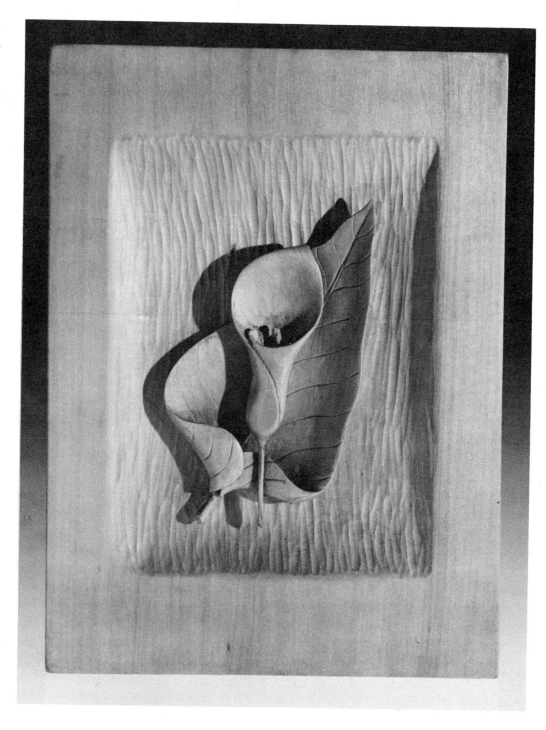

They Call It the Calla Lily

But it is not a lily nor an arum, though beloved of porcupines.

Called the trumpet or arum lily as well as the calla lily, this plant is neither an arum nor a lily. It is, botanically, *Zantedeschia,* and this species is *aethiopica.* It was, in fact, called pig lily by the early settlers because porcupines, which the settlers called pigs, liked its fleshy roots.

As a carving project, this flower and leaf are interesting and challenging because of the thinness of the edges. Cupping of the leaf provides the opportunity to round the base of the trumpet flower, but the curling edge of the leaf is very fragile when undercut; it should not be cut thin except on the very edge and should not be undercut to approximate true thickness. The same applies to the edge of the leaf and the edge of the flower. Properly and painstakingly carved, the flower is a very interesting one with an inner curl and a spadix standing out. If the wood is soft, like the basswood I used, it may be helpful to stabilize the edges before final shaping. Depth of grounding is ½ to ¾ in. to provide for the shaping of leaf and flower trumpet.

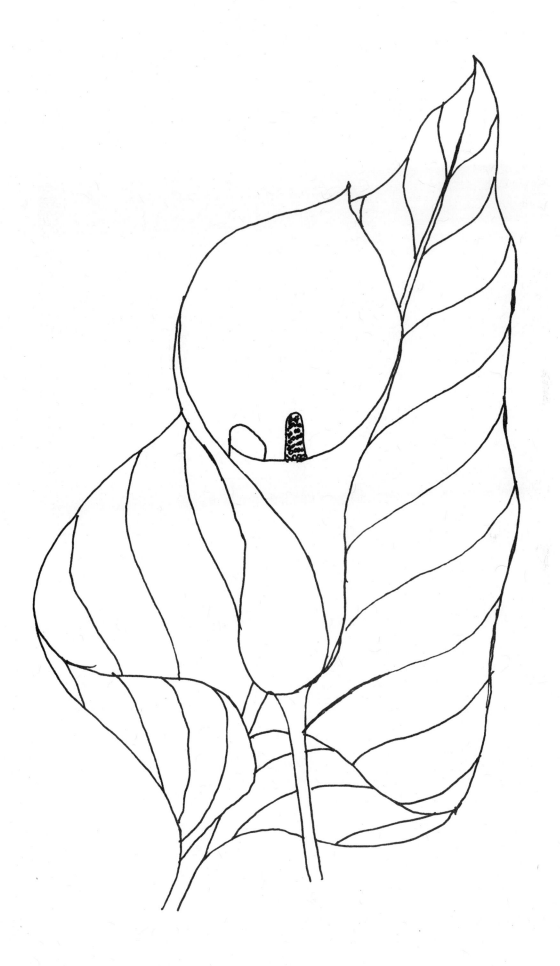

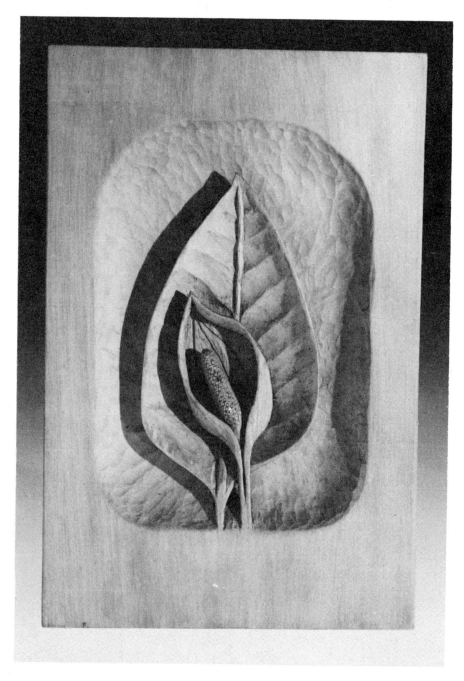

Spring's First Flower

The skunk cabbage has been a lifesaver, despite its name.

Credited with saving the lives of many Northwest Coast Indians, the skunk cabbage really suffers from two bad names put together. The first flower of the spring, the western variety (*Lysichiton camtschatcense*) blooms in swamps along the Pacific Coast in February through May, with green flowers in a club-shaped spadix enclosed in a showy yellow spathe. Blossoms precede the leaves, which can grow to three feet long in dense clusters. When fresh, the scent of the flower is very sweet, but older or crushed flowers or stems give some excuse for the common name. The roots are very hot and peppery, but bears and elk will tear up a whole marsh grubbing for them. When famine threatened in the spring, the Northwest Coast Indians used to cook the roots in pits together with scrapings from the inner bark of the hemlock, which killed most of the peppery flavor and made it quite passable as food.

The design used here is of the blossom backed by the leaf. It is not a complicated carving and there are few fragile areas except the edges of the spathe. The leaf is curved and strongly ribbed, and should be undercut to accentuate its shape and the curvature. Its hollow provides depth for the bloom, which in turn provides depth for the spadix of flowers. The latter is tightly filled with blooms, which are not individually carved but suggested by cross-hatching with the V-tool, $1/16$-in. veiner or a punch, made as described with the dahlia pattern.

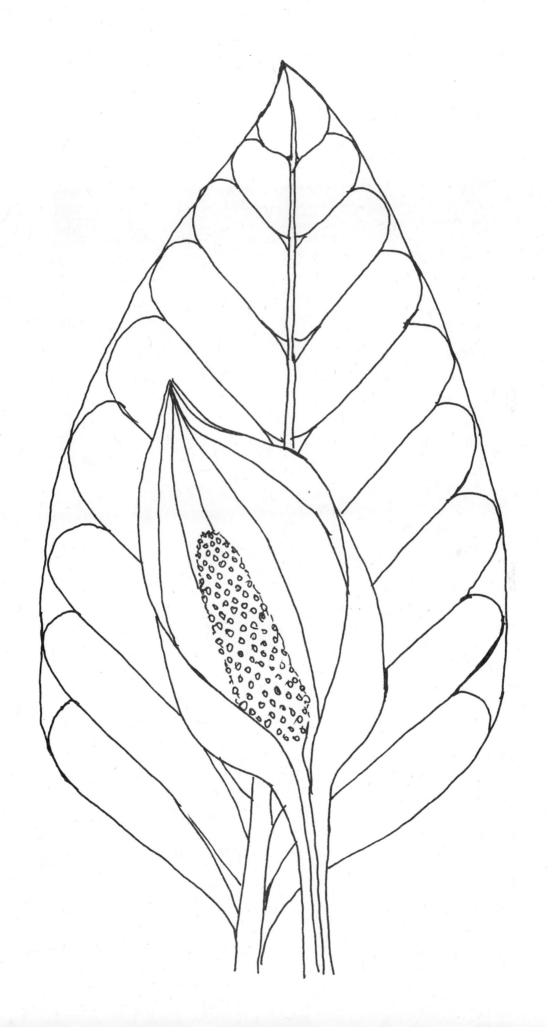

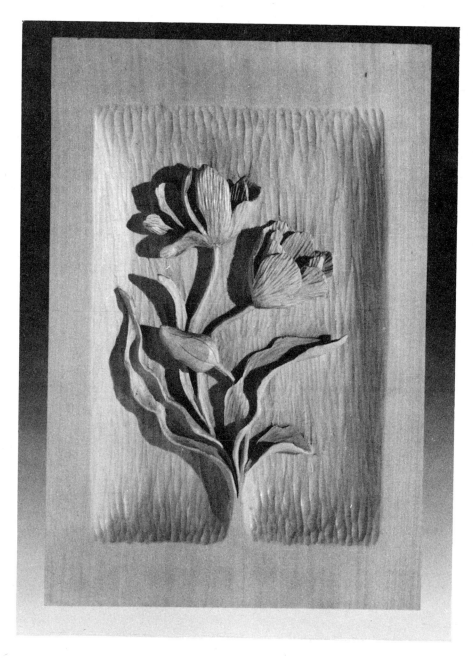

Tulips A-Tiptoe

A less familiar view and treatment offers challenges in petal and leaf shapes.

The tulip is familiar to everyone as a spring garden flower in many colors; we in America import bulbs for the common flower shape that every child learns to draw first or second among flowers. But the tulip is the national flower and symbol of the Netherlands, although it originated in Turkey before 1500 A.D., and has been developed in a great variety of shapes and sizes. This pattern, originally developed to challenge someone seeking a corner or center design for needlework, shows ragged-petal tulips in unconventional arrangement, with curled-edge leaves as well.

The wood is Oregon white pine, 2 × 10 × 14 in. I left 1¼-in. margins at the sides and 1¾-in. margins at top and bottom to suggest a frame, and trenched in from all sides in a sloping curve to a depth of 1 in. around and amid the design. The background

was then textured with vertical lines made with a small flat gouge. One problem with a design like this is to avoid flat areas on the upper surfaces; this requires careful sloping of curves from front to back so they have no apparent stopping place. Also, leaves and blooms are undercut to preserve shape and emphasize shadows. Note that the stem is lifted to bleed into the bottom margin.

The depth of the background permits clear separation of overlays, such as that of the bud over the flower stems and the characteristic wrapping of the hollow leaf around the thickish flower stem. Inevitably, of course, petals must be thicker than they are in life, but an appearance of thinness is attained by thinning the edges and showing the multiple crinkling.

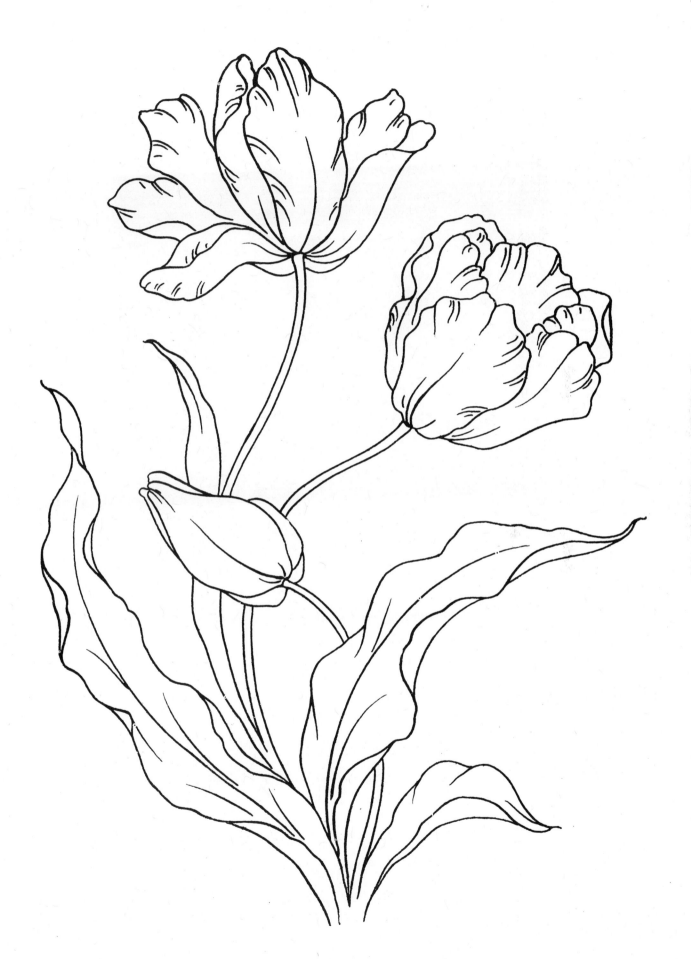

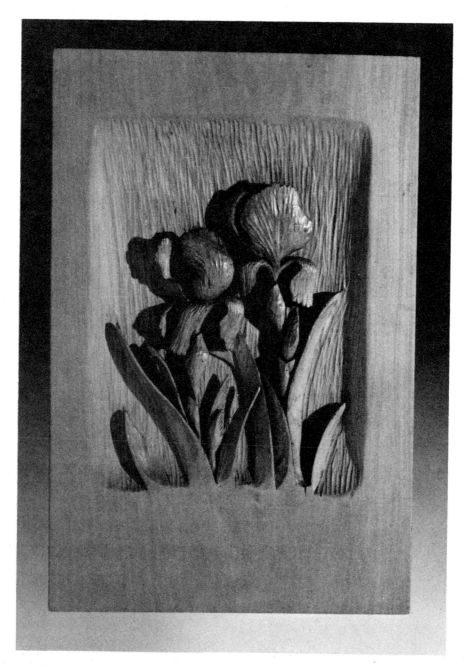

The Multicolored Iris

Familiar in many gardens, this flower is a challenge to carve.

A well-known flower of pond and stream is the iris from Europe, Asia Minor and North Africa. It is also the fleur-de-lis of France, a name supposedly acquired from Louis VII, who chose it as his emblem when he joined the Crusades. One theory is that "fleur-de-Louis" became corrupted to "fleur-de-luce" (light), then to "fleur-de-lis."

Color range for this flower, now hybridized, is very large, including white, yellow, orange, brown, pink, red, purple, lilac, blue and gray. In fact, the standards (upright parts) can be a different color from the falls (lower parts). As planted in most gardens, this is a spring perennial. The pattern is for *Iris germanica*.

The crisp, curling, lettuce-like petals of this bloom require careful carving and texturing, as well as some undercutting to simulate the thinness of the petals. However, the undercutting should be strictly limited so that the actual petal sections are as thick as possible or the texturing will cut through the edges. It may be preferable to do the outside or visible texturing first and thin the petal afterward. Stabilizing with #5 shellac (see Aztec lily for instructions on preparation) may also help to strengthen thin edges, and tools must be kept very sharp so they do not drag or exert undue pressure. It goes almost without saying that many small cuts are advisable, each taken without much pressure. Depth of grounding is about ½ in. The finished carving in basswood can be tinted if you wish with oils, watercolors or acrylics.

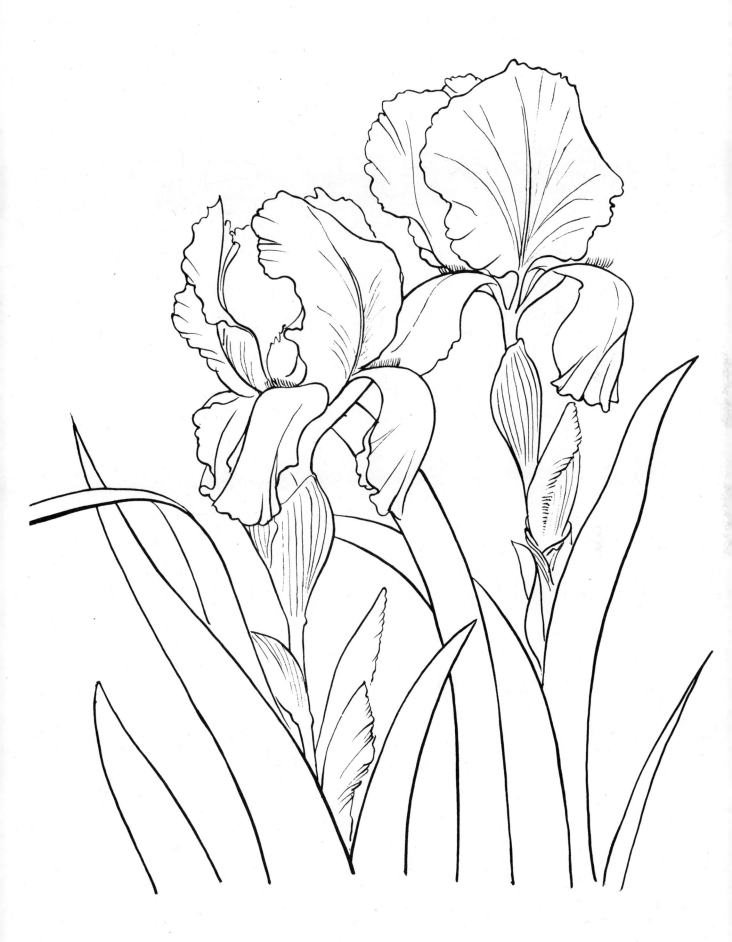

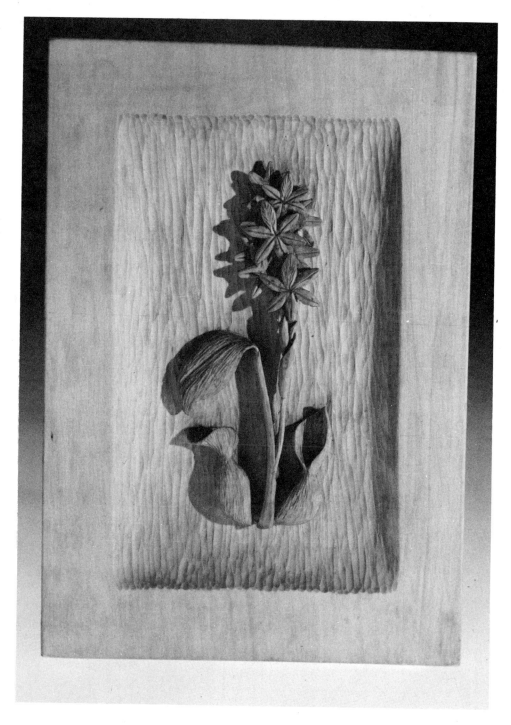

Water Hyacinths Ahoy—or Avast

A good carving, but a pestiferous plant.

The water hyacinth (*Eichhornia crassipes*) has a beautiful blue bloom resembling that of the familiar hyacinth, but it has developed into a pest practically all over the world because of the speed with which it proliferates. It grows in floating clumps that form islands, clogging waterways and impeding navigation. It can cover the surface of a lake in a couple of years, killing other vegetation and the fish life as well.

It is, however, a challenging carving project because of the six-petalled flowerets clustered around the stem head, as well as the unusual central-folded leaves. Undercutting to some degree is imperative to make the flowerets stand out, but this must be done very carefully without undercutting the petals so completely that they are left without support. Again, the background is down about ¾ in. for modelling of the leaves and separation of the flowerets, as well as for setting the flower head in the round above the stem. In this instance, I left the background with a pattern of cuts made with a flat gouge. The piece is 1 × 11 × 14-in. basswood.

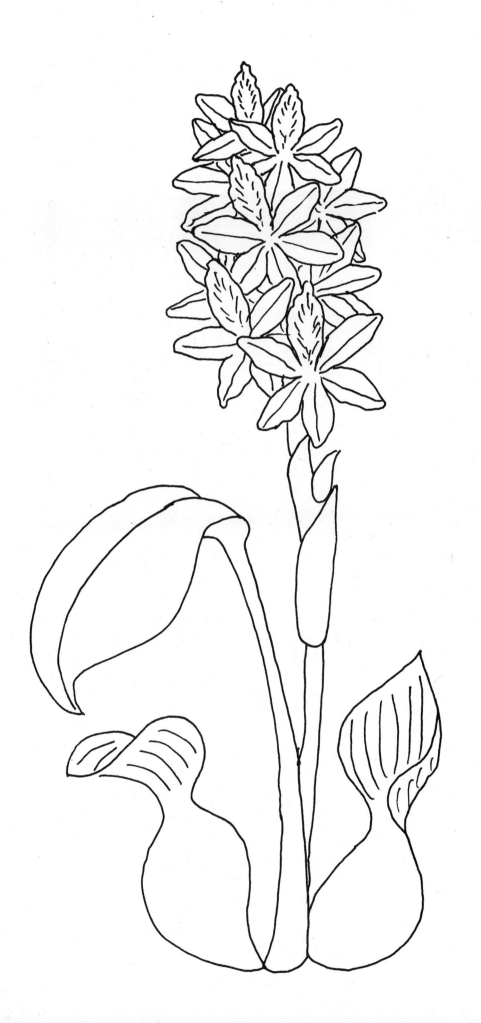

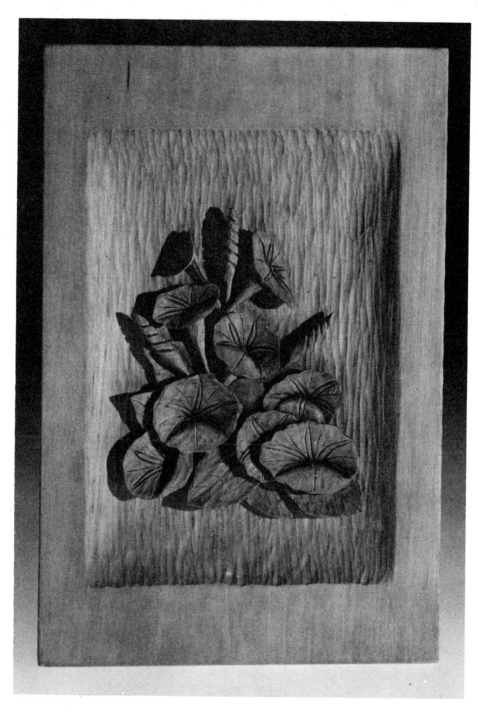

The Glory of the Morning

Tedious to carve, but very attractive to display.

This busy design made me want to throw it away at times, but the more I carved on it the better I liked it, and it is an attractive finished panel. It is the familiar morning glory (*Convolvulus*), which grows along roadsides and up and down anything and everything, and is also a standard plant in the old-fashioned flower garden. It has broad leaves and a five-lobed flared bell of a flower that grows in profusion and is quite showy, even as a spiral bud.

This is not a difficult carving, but it is a bit tedious because it has so many repetitive elements. Again, the levels must be care-

fully preserved to give proper effect, so undercutting and fairly deep grounding are required. The design is in effect a clump, with a decided third dimension created by the blooms projecting above the leaves, and the stems behind them. Also, the two upper blooms are shown from the side and should not look flat in front, that is, on the side toward the viewer. The vine itself has small tendrils that twine around whatever support the plant can find; one of these is shown in the sketch at the top. This can be added, if desired, simply by carving the shape into the background with a V-tool.

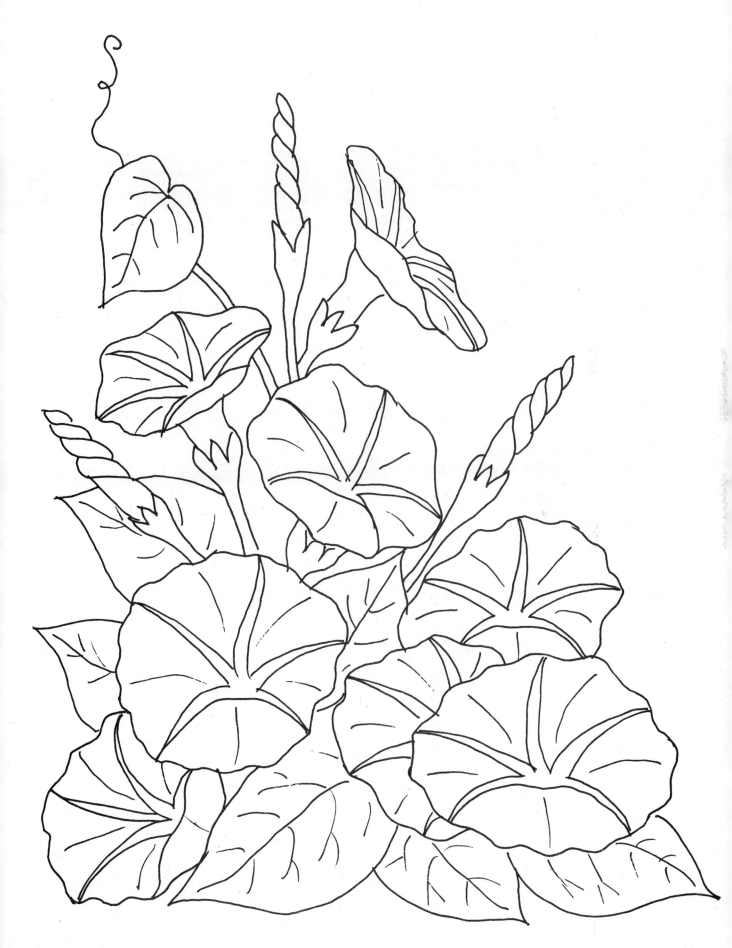

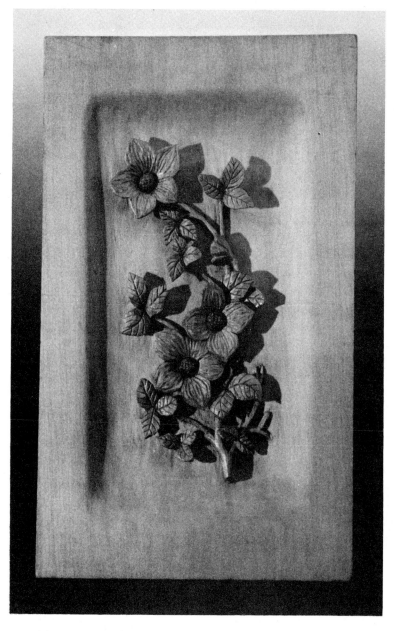

The Legendary Dogwood

Lovely and useful, this tree has several varieties.

Many legends surround the dogwood, the best-known perhaps being that it was the tree from which the cross for the Crucifixion was made, and that thereafter the tree was granted the boon never to grow large enough to make another cross. The wood is very hard and strong and has been used for years to make weaving shuttles because the tips do not shatter under the blows of the picking stick. For the same reason, it is used as a substitute for boxwood in making mallet heads, chisel handles and bobbins. The dogwood's bark is bitter and the tonic astringent derived from its bark has been used in place of quinine by Oregon Indians (as reported by the ornithologist John Kirk Townsend on his visit in 1833) and by Confederate troops during the Civil War. There are several varieties of the dogwood, this being the pacific (*Cornus nuttallii*). Its flower is not quite like that of the eastern dogwood, in which the four white, petal-like

bracts are cleft on the ends like chin dimples. (Also, the eastern dogwood has opposed branching, not alternate.) The flowers appear in April through May, and precede the leaves; the tree may bloom again in the fall. It also bears orange berries beloved of birds.

This can be a difficult carving if the undercutting is very deep—a stabilizer is a must. As such, it becomes an advanced carving project. However, if the grounding is held to ¼ in. or less, the carving is relatively simple, although not nearly as much modelling can be done. Tangerman reports, however, that a number of his students have made panels of the eastern dogwood as early projects, and in quite low relief. This panel can be hung vertically as shown or rotated 90 degrees to the right for horizontal hanging.

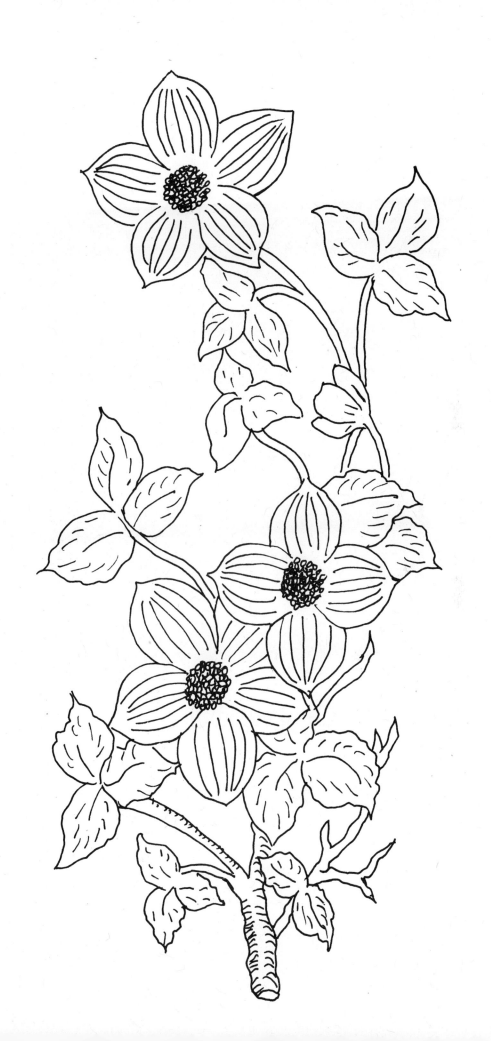

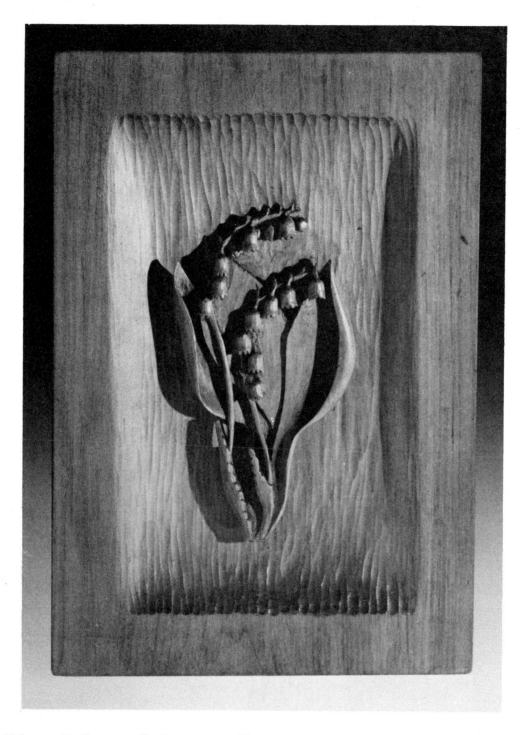

The Shy Lily of the Valley

A woodland beauty yields to careful carving.

Finland's national flower is very familiar to Americans in the early spring. The lily of the valley (*Convallaria majalis*) can be a difficult carving project because of the relatively small and detailed flowerets and the curling leaves. But the result is well worth the challenge, and the viewer will almost always recognize and identify with it. Grounding need not be more than ½ in., which is deep enough for the bells; the curling leaf at left must actually be curled more than it appears to be. The visual effect of a broad leaf is obtained by the gradual curve of the back and the under-cutting; actually the leaf is ¼ in. or more thick shortly behind its edge. Also, the bells appear to stand free, but each is anchored in back against the ground or the leaf or the bell behind it. Cutting the bells free is unnecessary and makes the carving too fragile. Bells are also not sanded exactly round; they are left with small planes from the tools. The only portions standing free are the spiralled buds and the left-hand stem, bridging the distance between the base and the lower edge of the left-hand leaf.

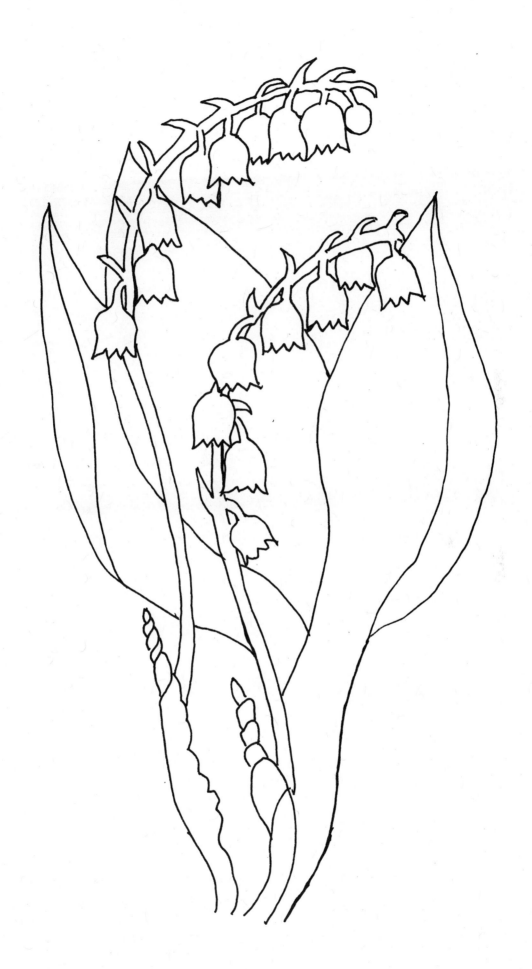

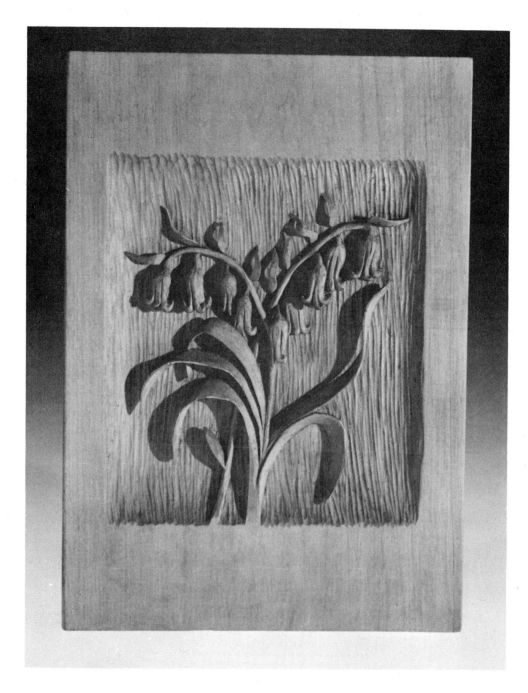

Bluebells Are a Challenge

A pleasing panel—but you must take care.

Several different flowers are called bluebells in various parts of the English-speaking world. One is the *Campanula* or harebell, in which the individual bells are upended. This, however, is the Endymion bluebell (*Scilla*), a deep-blue flower with decided lobes hanging down from a stem which also bears leaflets extending upward. From a carving standpoint, this is an edgy design, like the lily of the valley, because a number of thin sections are across grain. Further, the bell shape should be undercut to make it stand out, but not so much so that it is free. The weakest spots, requiring most care, are the tips of the petals and the stem. The lower leaves are turned partially, so they can be undercut somewhat but will still retain a triangular cross-section.

In carving such areas as stems, it is advisable to protect the delicate area as long as possible, particularly when the stem is across grain. There are two ways to do this. One is to carve the stem wider initially and to thin it only when final undercutting is being done. The other is to leave the background high enough where the stem is so it can be cut to size and shape in the final operation. For cutting such as this, thin blades are almost a must because they do not crush the wood. Basswood is easy to carve, but it is also easy to crush by forcing in a tool, and this causes crumbling and breakage.

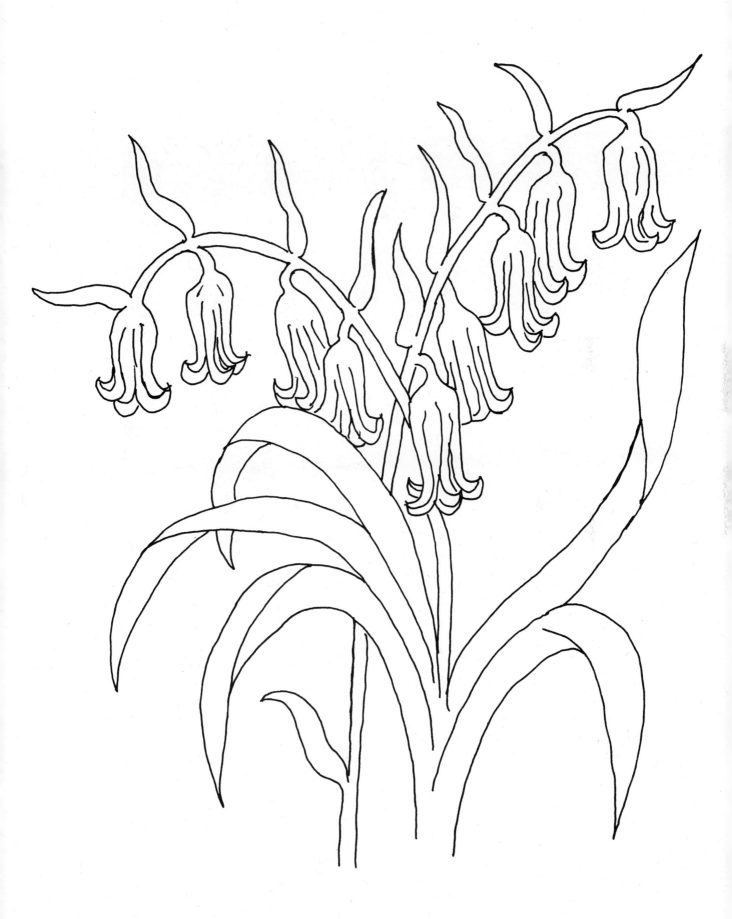

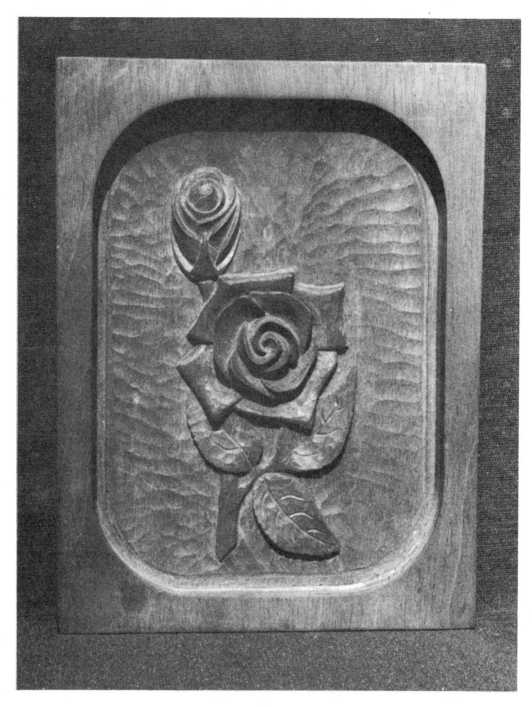

A Rose Is a Rose . . .

Best known among flowers, the rose is a familiar carving project.

Celebrated for centuries in song and story, the genus *Rosa* is probably our best-known flower. The wild rose is the state flower of New York, North Dakota and Iowa, and is five-petalled; it came originally from the Orient. About thirty wild species have been hybridized into more than four thousand horticultural varieties. The cultivated rose is the floral emblem of England, dating back to the Wars of the Roses (1455–85) between the Houses of Lancaster (red rose) and of York (white rose). The rose has been a common element of decoration and of wood carving, including the Tudor rose used extensively in West-

minster Cathedral, and the Luther rose in Germany. It is also a familiar relief-carving project.

This rose was designed and carved by T. E. Haag of Tualatin, Oregon, and is carved without undercutting. The original wood was 1 in. thick, of which ¾ in. has been cut away to make the background. The essential problem with this design is to work carefully around the upright petals; other than that it is not too difficult.

Mr. Haag has framed his carving with a precise geometrical and vertical border, outlining a flat-gouge-carved background.

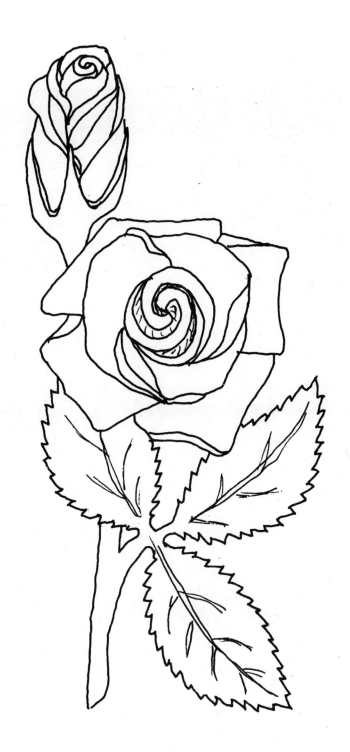

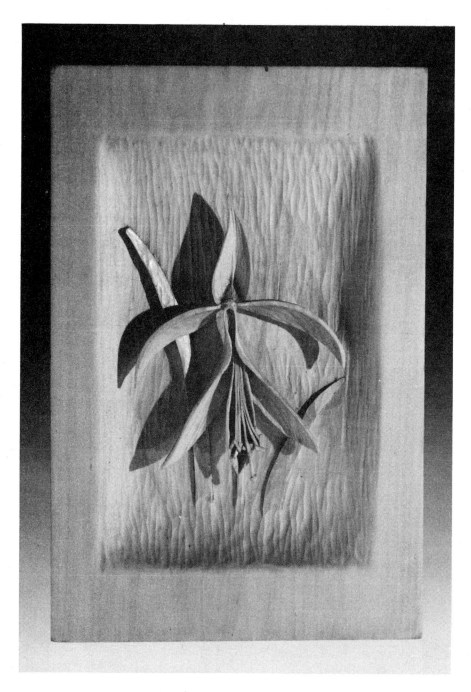

The Lily of the Aztecs

From south of the border, this flower is our most difficult carving.

Bearing handsome flowers that resemble those of the Cattleya orchid (see orchid pattern), the Aztec lily is also called the orchid lily, Jacobean lily, or St. James lily. The botanical name is *Sprekelia formosissima,* and it is a native of Mexico and Guatemala. The flower makes a beautiful and striking display, and so does the carving. But it is probably the most difficult of any shown in this book because the blossom touches the background in only three places, and many sections are very thin, particularly the long and dangling stamen and pistils. The answer is, of course, very slow and careful work with small tools. If it is carved in soft wood— and perhaps even if carved in a harder one—it is advisable to stabilize and strengthen the carved areas with frequent coats

(between bouts of carving) with a mixture of "#5 shellac," prepared as indicated on page 12.

The shellac mixture dries quickly and does not discolor. We are using it, in fact, to protect the surface of the wood from being dirtied during carving, putting a coat on face and sides of the wood as soon as the design has been drawn and replacing the coating when areas are carved. In areas of delicate carving, like the stamen and pistils, we give the wood several coats to strengthen it before attempting carving. After carving is completed, additional coats of the mixture can be applied until the desired degree of gloss is attained.

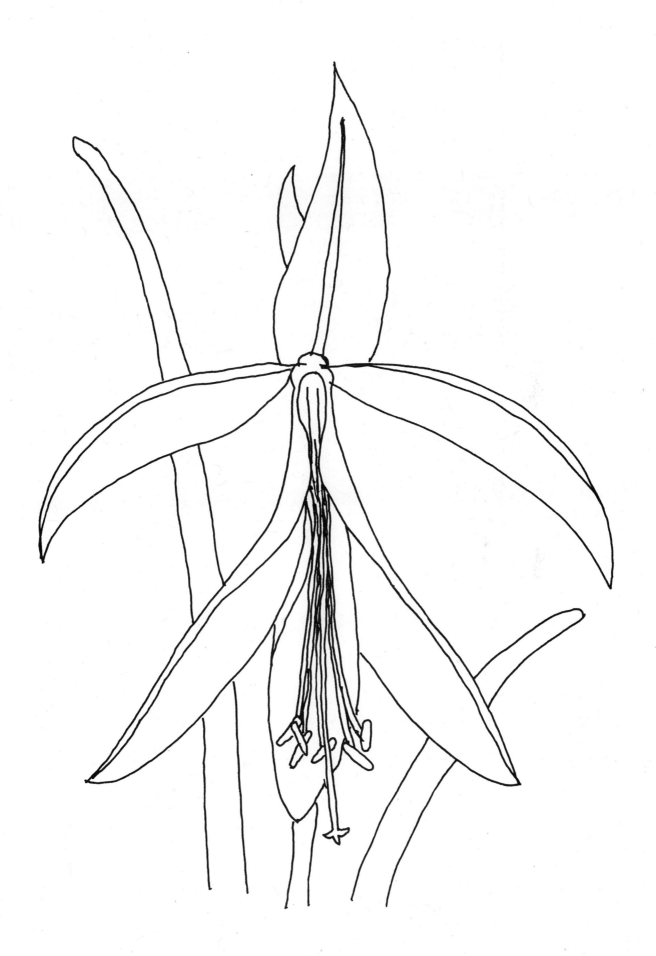